PEN MIND
BEGINNER'S MIND

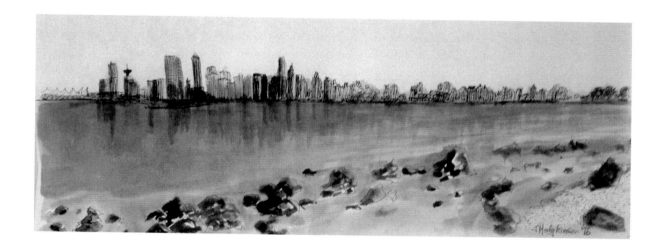

A MINDFULNESS APPROACH TO BEGINNING TO DRAW

Jim Hodgkinson

Gateways Fine Art Series
Gateways Books and Tapes
2017

COPYRIGHT PAGE
Text ©2017by Jim Hodgkinson
Illustrations ©2017 by Jim Hodgkinson/ Gateways Books & Tapes
Art by Jim Hodgkinson
Cover design and Interior layout by Gailyn Porter
All Rights Reserved.
Printed in the U.S.A.
First Edition
First Printing 5/1/17

Published by:
Gateways Books and Tapes
P.O. Box 370
Nevada City, CA 95959
Phone: (530) 271-2239
Email: info@gatewaysbooksandtapes.com

Library of Congress Cataloging-in-Publication Data

Names: Hodgkinson, Jim, 1948- author.
Title: Pen mind, beginner's mind : a mindfullness approach to beginning to
 draw / Jim Hodgkinson.
Description: First edition. | Nevada City, California : Gateways Books &
 Tapes, 2017. | Series: Gateways fine art series | Description based on
 print version record and CIP data provided by publisher; resource not
 viewed.
Identifiers: LCCN 2017009099 (print) | LCCN 2017010989 (ebook) | ISBN
 9780895565884 (ePub eBook) | ISBN 9780895565891 (pdf eBook) | ISBN
 9780895565907 (MobiPocket eBook) | ISBN 9780895562791 (paperback)
Subjects: LCSH: Hodgkinson, Jim, 1948- | Artists--Alberta--Anecdotes. |
 Drawing, Psychology of. | Drawing--Technique. | BISAC: ART / Techniques /
 Drawing. | SELF-HELP / Creativity.
Classification: LCC NC143.H63 (ebook) | LCC NC143.H63 A35 2017 (print) | DDC
 741.092--dc23
LC record available at https://lccn.loc.gov/2017009099

Preface

I'd never considered myself an artist. As a chemist, a technology instructor and a technical writer I would sketch diagrams or make little explanatory drawings but for publication they would go to a graphic artist. A year or so after I retired from teaching I became aware of an interactive online drawing course due to start in August of 2014. Given by Dr. Christiane Wolters, it was based on artist E.J. Gold's "Draw Good Now" teachings, given as an online class while Mr. Gold conducted his in-person art classes.

Here is the advertisement for the course which caught my attention:

"We will start with "Pencil Magic" on Friday, August 8, 2014 at 10:30 am PST. We will review the basics of shading, border, scribble and the figure ground exercise. Everything else is pencil mileage and expansion, deepening and exploration – all the way down – or is it up – or in…:) – of these basic tools. Open to all, and especially those who don't consider themselves real artist. This weekly art hour is hosted by Dokgoth. Pencil Magic is inspired by the "Draw Good Now" series by E.J. Gold and a letter Kurt Vonnegut wrote to students – practically imploring them to do art – to grow their soul."

This book is a chronological record of my growth as an artist from that point in time to the present. The focus is on drawing, initially using graphite, then later pen and ink wash. The book shows a drawing on one page and a few pithy lines of commentary on the facing page.

On the way to accepting myself as an artist two things became clear. First, drawing can increase your awareness of the world around you and second you can recapture your child-like sense of wonder and exploration - your "Beginner's Mind". It is my sincere wish that through the telling of my story you discover your beginner's mind.

Jim Hodgkinson
March 2016

Index

Introduction

What is "mindfulness"? It's become a bit of a buzzword and I shamelessly used it in the title of this book in the hope that it would connect with a potential reader. But what do I mean by "mindfulness"? For my purposes it simply means noticing something. Actually noticing, not thinking about it or remembering it but connecting with something NOW. Placing your attention on it then seeing it.

The visual nature of drawing places emphasis on a "seeing" type of noticing. You want to draw a tree in the local park. You sit comfortably on a nearby bench with your sketchbook on your knee and take a soft graphite pencil from your pocket. It's a bright sunny day in the morning - the sun is in the south-east. You notice the shadow cast by the tree, it's direction and length. You notice it is darker at the base of the tree. You notice the texture of the bark on the tree, the deep grooves and furrows. You notice your mind kicks in now as you wonder how you're going to capture those grooves in your drawing. You place your attention back on tree and notice the general shapes of the branches. Hmm... they're very linear, not many curves.

You begin to draw, placing attention on the page. Then the tree. Then you notice the mind has chimed in again. And so on and so on. Drawing automatically exercises your skill in focusing your attention. Noticing your self, your thoughts and feelings as you draw, is of particular value in becoming conscious.

Many of us don't believe we can draw well. We recoil at the thought of showing someone our work. We dread the anticipated criticism. For want of a better word, this is coming from our "ego" or identity. You don't think of yourself as an "artist" and feel uncomfortable saying that about yourself. Notice these thoughts and feelings as they arise.

Noticing your ego in action means you simply notice it. You don't judge what comes up. But if you do judge - just notice that too. Noticing has a space of indifference around it. It's just the facts as they are. No more no less. For want of a better word, that space is your "beingness".

Noticing or mindfulness is a way of becoming more conscious. Creating art can become a spiritual practice when it is infused with noticing or mindfulness. At this nexus or contact point of ego and being, the "beginner's mind" can arise. The beginner's mind is what you had as a small child. Your learning was filled with wonder and exploration. Your ego had not yet developed into a restrictive box.

There is a way you can begin to draw and get back your beginner's mind. I know, because at the age of sixty-six this happened to me.

The Blank Page

The Blank Page

All things are possible here
At the nexus of ego and being
If I can just move past the wall of inertia
Built of false beliefs.

So many questions
What shall I draw
How do I draw
Can I draw?

As I sit with this blank page
I just sit and
My Beginner's Mind
Comes from background to foreground.

My Beginner's Mind.
I can learn to draw.
I can make drawing a daily practice.
Just a little each day.

Over time I will improve
And it will be fun
To achieve something
I believed was impossible.

I am at the nexus of being and ego.
The Beginner's Mind.
Filled with the wonder
Of exploration.

First Steps

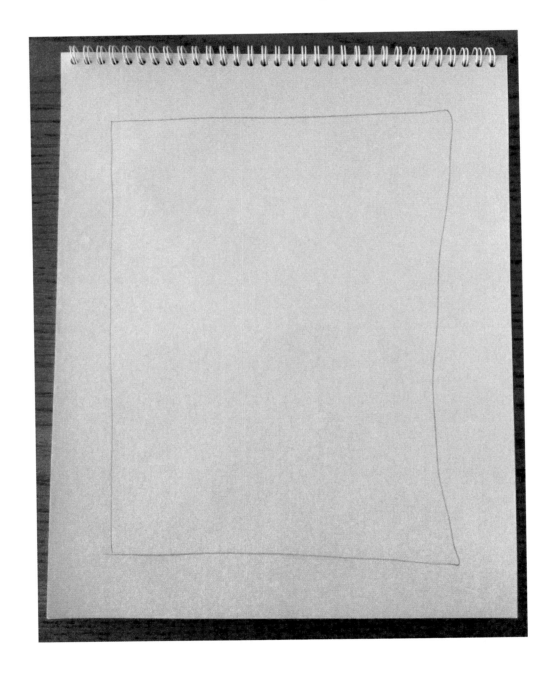

First Steps

Without thought,
On the out-breath,
I begin to draw the border.

Lower left, up
Upper left, right
Upper right, down
Lower right, left.

No thought,
No decisions,
Just a smooth motion
During the out-breath.

A small bounded space
Of my own
To bring something
Into being.

Light And Dark

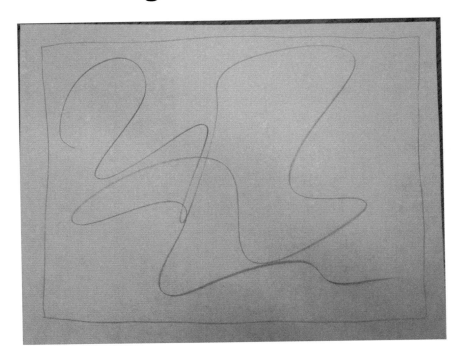

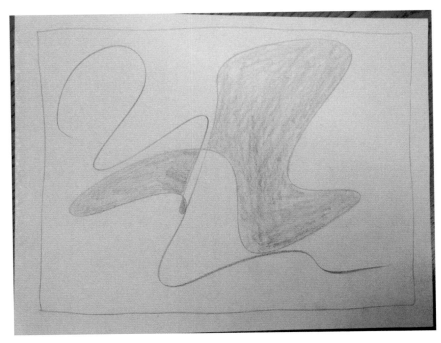

Light and Dark

In my first drawing lesson
I used a pencil to
Scribble in one continuous motion,
Pencil point on the page until the end of the breath.

No thought,
Just a smooth looping motion
With no breaks
From the top left to bottom right.

I've made a mark.
As I look at the mark
I sense shapes
Trapped within it.

I'm going to bring them out
With shading,
Selecting shapes
As they make themselves known.

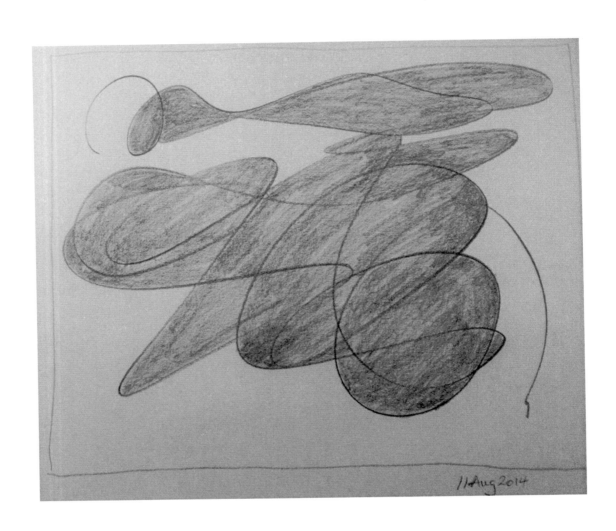

8

My daily practice has become to scribble without thought
And to bring out the hidden shapes.
I am happy to do just this. As the days and weeks go by,
I begin to sense solid forms In the drawings.

I wonder how I can bring out a sense of mass, of dimensionality.
How can I make the forms appear three-dimensional?
And I discover through my classes
A new way to shade.

I start to shade with the flat side of the graphite.
Not the point.
I try varying the pressure on the graphite.
I try varying the angle of the graphite.

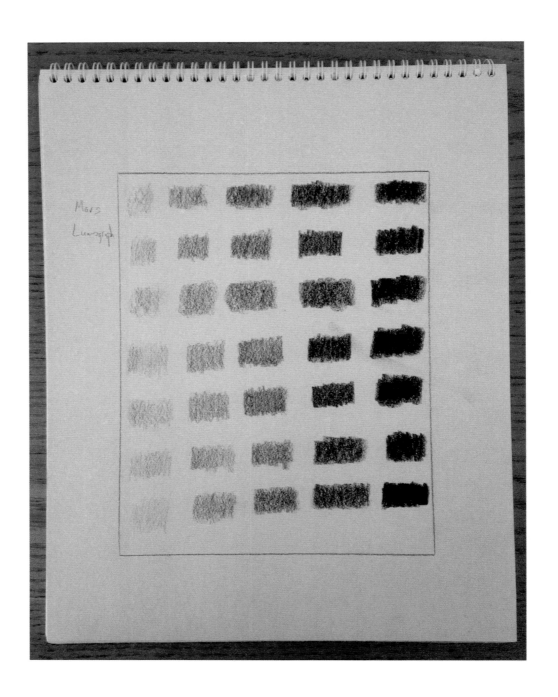

I'm delighted with this new shading method.
I can start to vary the shading from heavy black to light gray.
What tells me that an object is three-dimensional?
What tells me that a surface is flat?

Flat objects have a uniformity in their reflectance of light
Three-dimensional objects do not.
Three-dimensional objects have areas of lightness and darkness
And they cast shadows.

Shading is going to be an important skill to master
To be able to represent objects and texture in my drawings.
I begin to extend my drawing practice to include shading.
I practice varying the degree of lightness and darkness.

Dimensionality

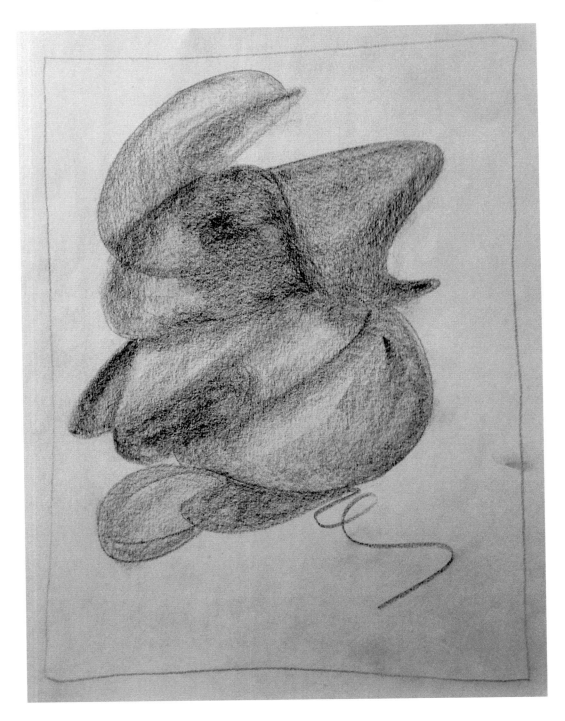

Dimensionality

I am beginning to realize the importance of deciding
Where the light source is In the drawing.
I have not yet realized the importance of contrast.

White next to black, to bring out shape and mass.
In time I will begin to see things.
For now I just stay on the path.

14

I am starting to feel pleased with my work.
The drawings sometimes surprise me
With an aliveness that I can't define.

I like that I like this path.
It is my path. I feel ready
To start exploring different media and subjects.

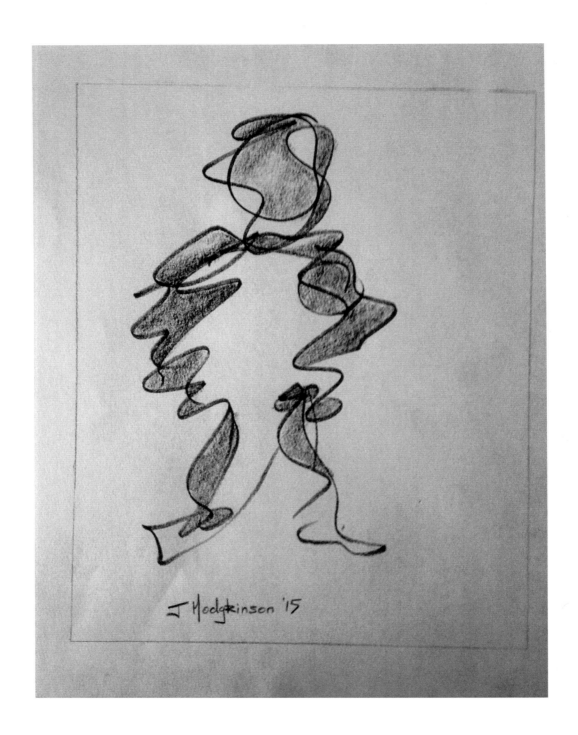

J Hodgkinson '15

Months have passed
And I have explored new media
Acrylics, charcoal and pastel but
I always come back to graphite.

Simple landscapes, portraits and figures too.
Then an experiment.
 A black ink marker for the outline
And graphite shading.

I like the bold contrast
Of black ink on the page
And without realizing it,
I have found my way.

Perspective

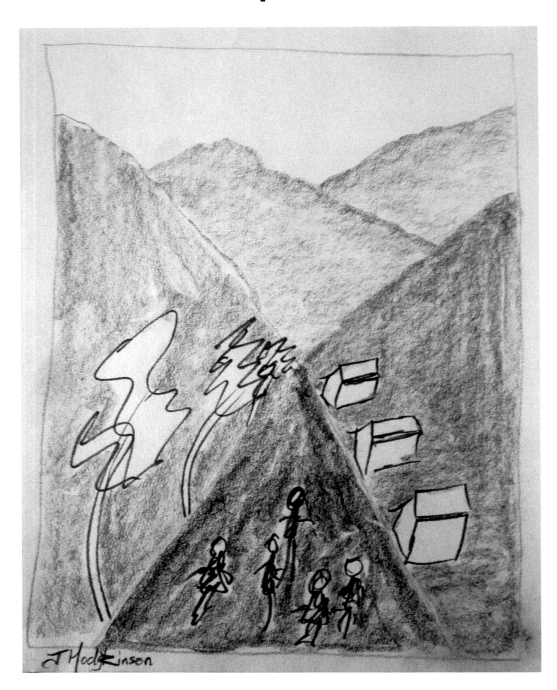

J Hodgkinson

Perspective

In this drawing, as well as representing
A road which seems to vanish into the middle
Of the drawing, I experimented with negative space
Leaving the trees and houses unshaded.

The white empty forms
Stand out starkly
Against the darker shadings
Around them.

Drawing landscapes and cityscapes brings up
The representation of distance.
In the country or the city notice
How roads appear as they recede into the distance.

I am the observer and my viewpoint
Is from the foreground, at the bottom of the drawing.
I see objects clearly when they're close.
As they get further away they seem smaller and less detailed.

Isn't it strange how as a moving car approaches
You see it first as a tiny dot then it gets bigger and bigger the nearer it gets.
But the road, trees and buildings near the car are also getting bigger
So I guess that's how we know it's coming down the road.

And not ……. Exploding! Ah relativity.

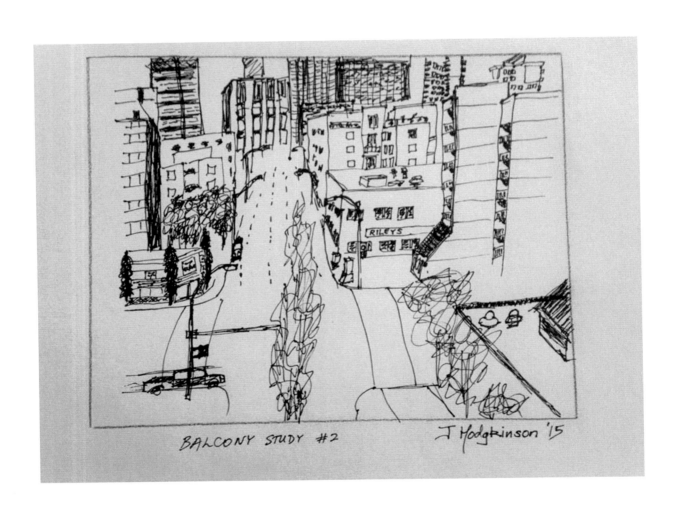

BALCONY STUDY #2 J Hodgkinson '15

Continuing to work in pen
I begin to draw from life.
Views from my downtown apartment
Provide convenient exercises in perspective.

Drawing from life
Is a new experience for me.
Up to now all my attention has been on the paper
Now I have to pry it away from the paper to look at the subject.

The switch to ink
Is still tentative
Like I'm not really serious
And kind of casual, using felt pens.

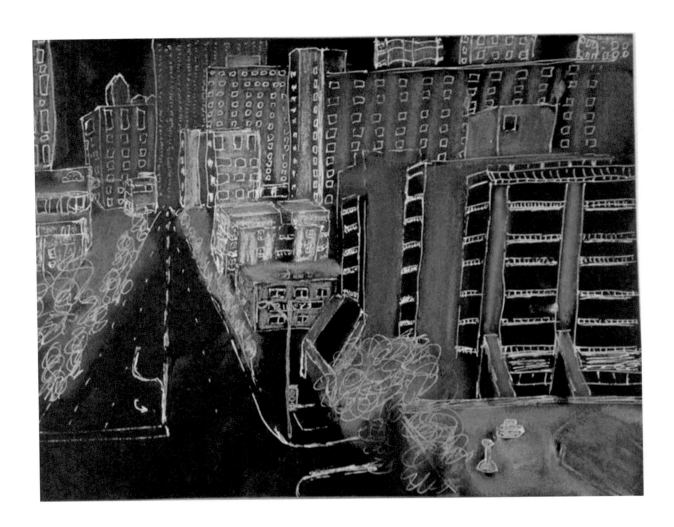

I continue experimenting with abstract acrylics
And in the midst of them I go to balcony again
And try to draw what I see in pastels.

Using black paper was a suggestion
By a fellow artist who'd seen my work
Posted on Facebook.

Posting on Facebook for your friends and family to see your work
Is an easy way to face
Those feelings of fear that you'll be criticized.

And my community of friends including many wonderful artists
Has always been kind and supportive right from the beginning.
It also gives you a photographic record that lets you look back.

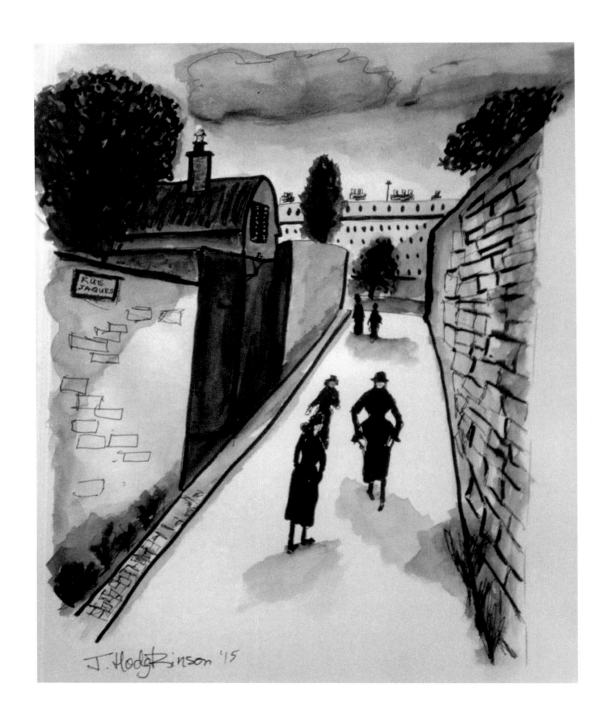

Having shown an interest in cityscapes
My teacher E.J. Gold recommended
I research the works of Maurice Utrillo

I was taken by Utrillo's representation
Of everyday life in Montmartre
And started to copy his work to become immersed in it.

Following advice has pushed me forward
Although I only notice this
In retrospect.

When I draw my own little figures
To inhabit my cityscapes
I know they were born in Utrillo's Montmartre.

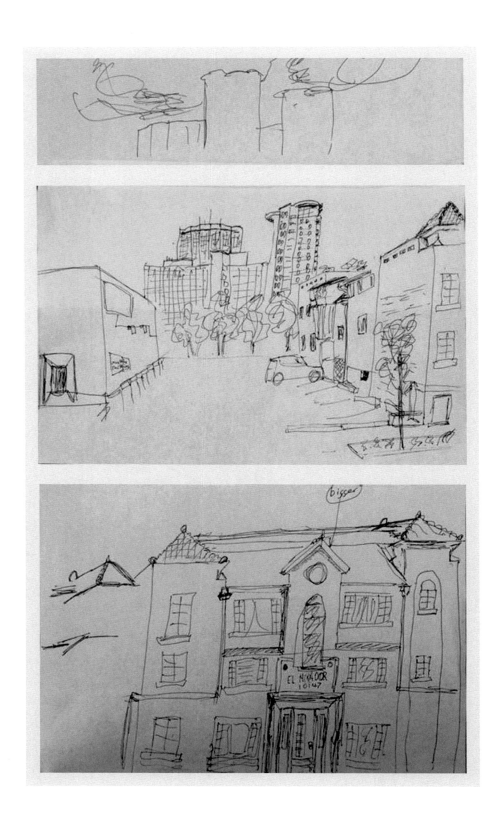

A little self consciously
I went for a walk near our apartment
Carrying my leather bag
With sketchbook, felt pens and pencils.

I walked a long time
Looking for an interesting subject.
Finally settling on a comfortable bench
That hot Summer day.

I just sketched what was
In front of me,
Having settled for comfort.
After all, it was an exploration.

Bit by bit
You absorb it
But don't be in rush
To see the results.

Just stay on
The Path
And one day look back
To see how far you've come.

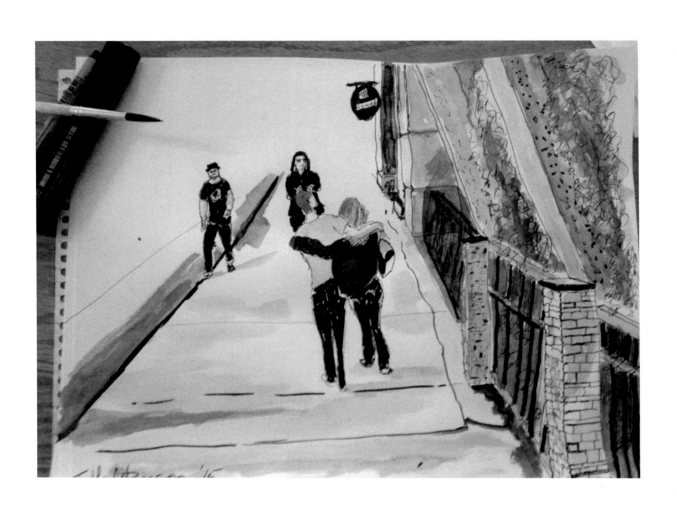

I started looking through photographs
Using internet image searches
Of areas I knew
In my city.

This subject was near the University
And there was a nice contrast
Between the the moods of the two couples
Approaching each other.

I used simple tools
Artist's black felt pens
A thick one and a thin one
And a small brush for India ink and washes.

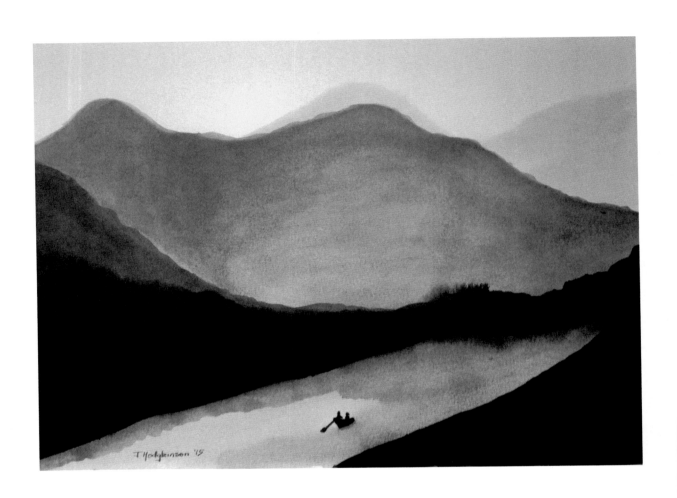

I began exploring washes
Using diluted India ink
And straight water
On mixed media and watercolor paper.

I was intrigued by
How dark bands of ink
Could bleed into water
Creating complex patterns.

Making landscape foreground dark
Mid ground lighter and
Background lighter still,
Gives a sense of distance.

If you are careful
You can build several layers
Of light washes
To get the desired effect.

In time I'll learn to "Look before I Leap"
And first check my diluted ink
On a scrap of paper
To make sure it's not too dark.

You can always add layers
But you can't
Remove them
When they're dry.

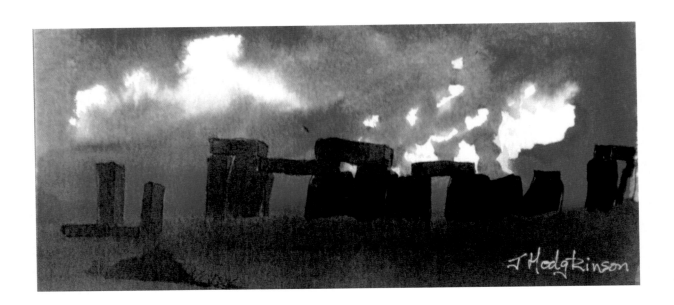

If you keep a tissue handy
You can use it to blot up wet ink
And get some interesting effects,
Like clouds.

I played with layers of blue ink wash,
Plain water,
And dabbing with a tissue
Until I got this cloud effect.

But the next day
I couldn't remember with my mind
How I'd done it.
I hope my hands remember.

Portraits

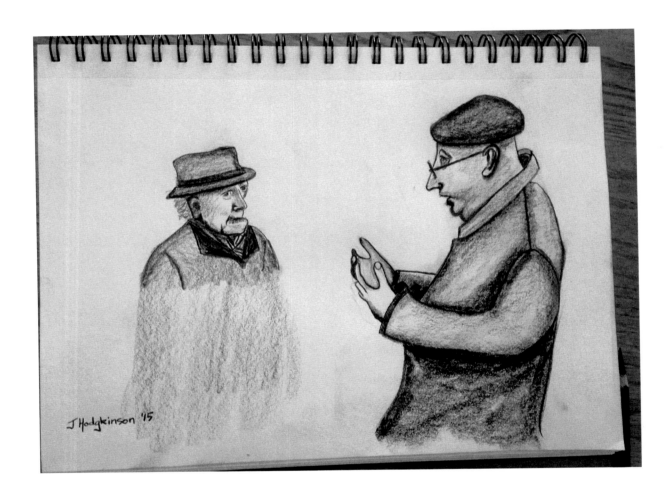

J Hodgkinson '15

Our teacher E. J. Gold suggested
We create a picture
Of two people
In conversation.

Using an Internet search engine
I found a photograph
Of two men in conversation
In a park.

I like that the two men
Have taken the time
To connect
And talk to each other.

Getting the proportions
Of the hands and fingers correct
Is a challenge
And I decide to practice drawing hands.

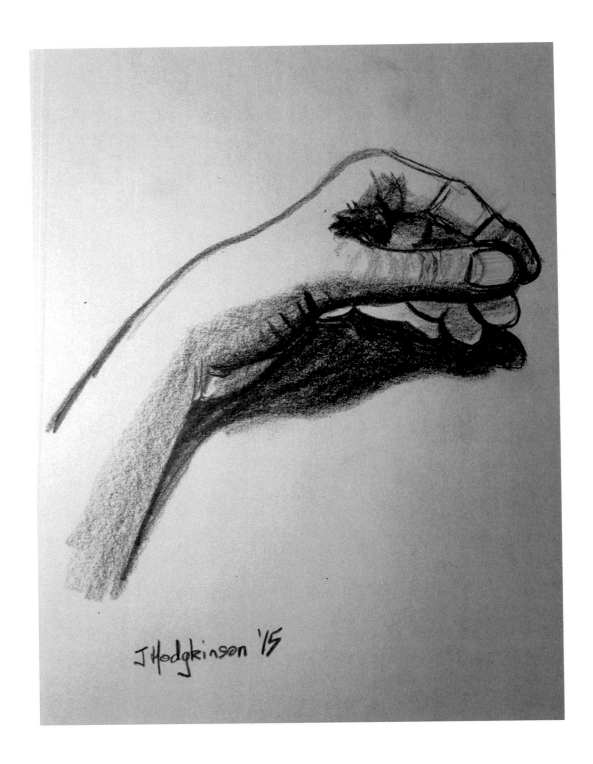

JHodgkinson '15

Hands and ears need practice.
Luckily I have two hands
And can use one as a model
While I draw with the other.

I sat at the kitchen table
With a bright overhead light
That created some intense
Shadows on the table.

Emphasizing the shadows
Brought out the shapes
And added a touch
Of realism.

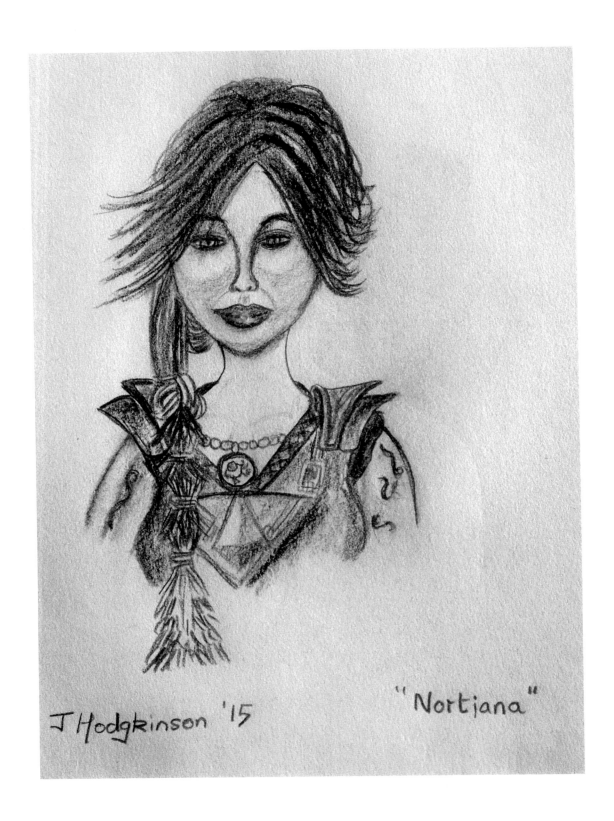

"Nortjana"

J Hodgkinson '15

Our teacher E.J. Gold suggested that
If you don't have access to a live model
You can simulate the experience
Using the virtual space of Second LIfe.

Nortiana and three other ashram friends
Graciously agreed to sit for me in
The Prosperity Virtual Ashram
In Second Life.

I created a raised stage
And some side lighting
To create shadows
On a frontal view of the face.

I booked a time with each model,
Positioned them for drawing
And moved my avatar's viewpoint
To best capture their faces.

When I had finished my drawing,
I photographed it and sent them
Each a copy, then digitally framed it
And uploaded it to Second Life.

I shared the framed drawings
With each avatar in Second Life
So that they could hang it
On the the walls of their homes.

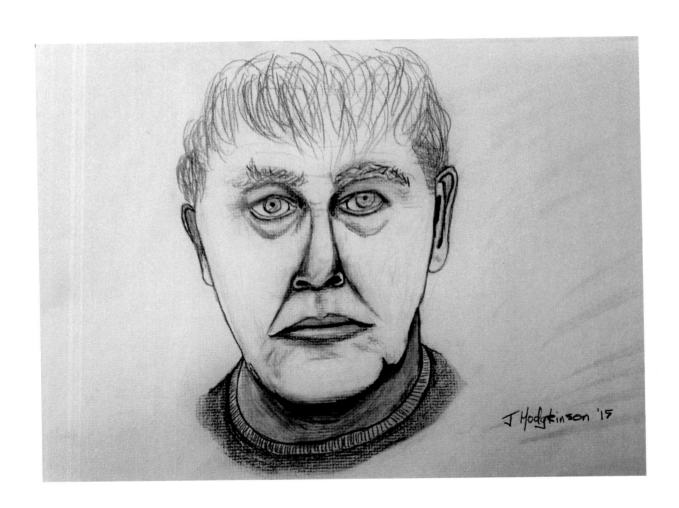

J Hodgkinson '15

40

I used a mirror to draw a self portrait.
Using yourself as a model
Let's you take all the time you need
To get the details right.

This was the first time that I tried
To get more detail In my drawings.
I am pleased that it
Actually looks like me.

Shadow Play

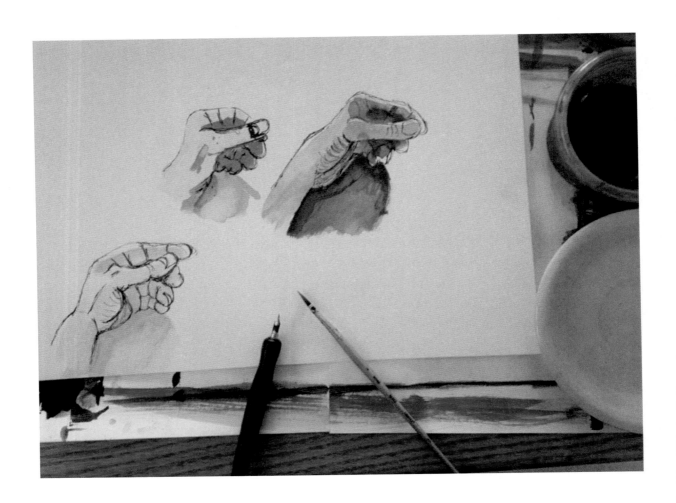

My teacher, E. J. Gold,
Suggested I research the work of
Albrecht Dürer, the German Renaissance artist
Known for his engravings and paintings.

Dürer's brilliant draftsmanship inspired me to
Pay attention to my tools and technique.
I began using a simple nibbed pen
Dipped in ink to draw fine lines.

I played with a small brush dipped in diluted India ink
To reproduce the shadows cast by lit objects.
A good beginning but
Control and nuance are yet to come.

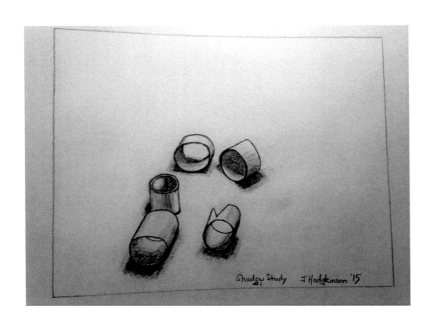

Shadow Study J Hodgkinson '15
#1

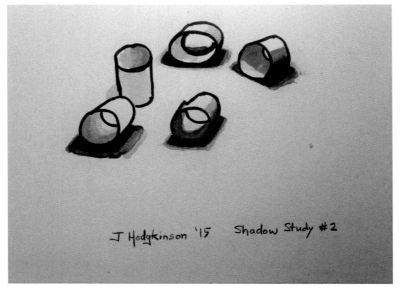

J Hodgkinson '15 Shadow Study #2

Our teacher suggested
A shadow exercise
Using small objects
Strongly side-lit.

I cut up some
Small sections of cardboard tube
Placed a single desk lamp to light them
And made drawings at night.

Observing shadows at night,
With darkness around you,
Let's you notice that shadows
Vary in their degree of blackness.

There is a penumbra,
An area of partial darkness,
On the outer edges of the cast shadow
And on the inner surfaces.

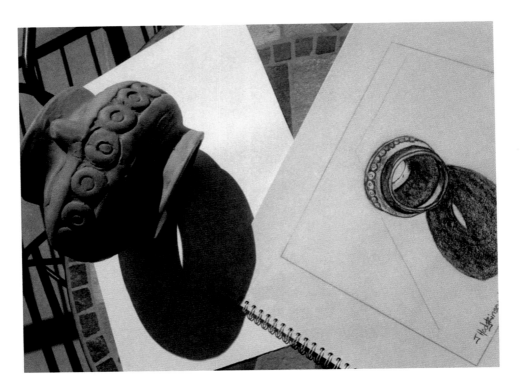

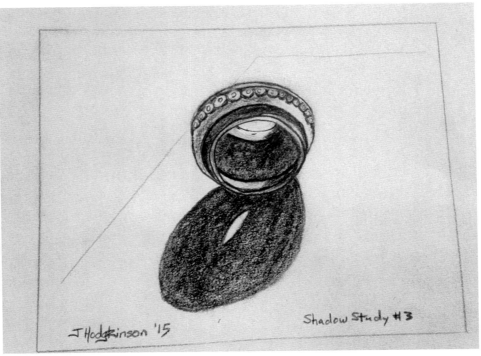

J Hodgkinson '15 Shadow Study #3

In another shadow study from E. J. Gold,
We were asked to look at the shadows cast
Internally and externally
By a cylindrical hollow object.

I used soft pencil to draw this open object
Using strong sunlight for the light source.
I positioned myself, my viewpoint,
To observe the internal light and cast shadow pattern

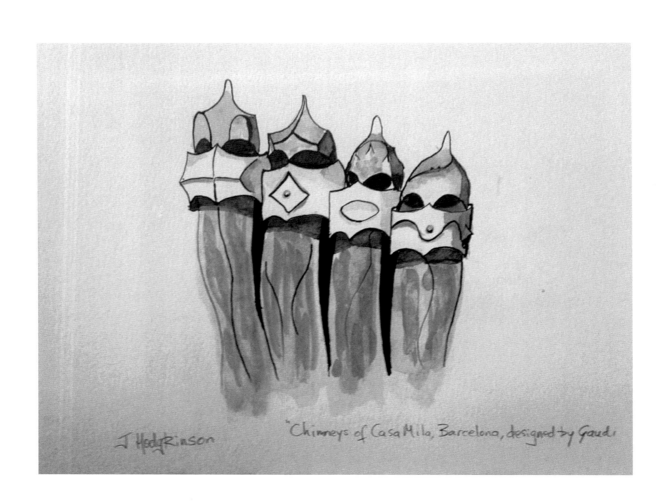

J Hodgkinson "Chimneys of Casa Mila, Barcelona, designed by Gaudi

I had visited Barcelona
A few years ago
And it reminded me of heaven
Or at least a higher plane of existence.

I think part of it
Was the architecture of Gaudí's
Free flowing forms
Influenced by nature.

And part of it was
The Gothic Quarter
With buildings dating from
Medieval and Roman times.

I was not ready to draw Gaudi's famous Casa Mila in its entirety
But I could handle the chimneys
Which offered different qualities of shadow
In the bright Barcelona sun.

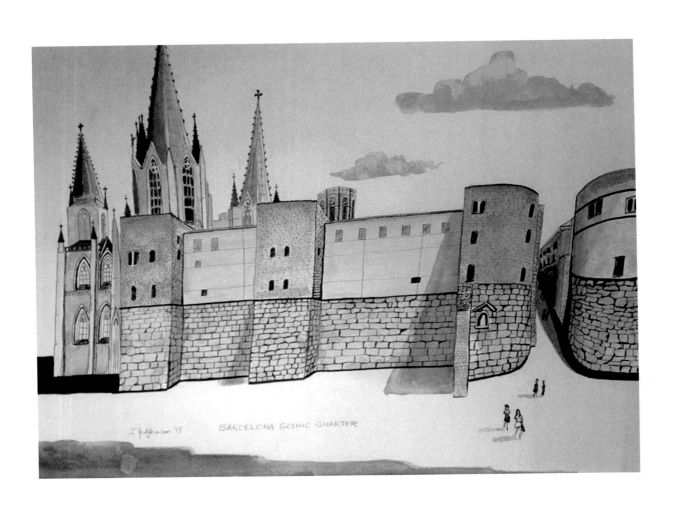

I remember seeing
The entrance to the Gothic Quarter
In person and up close
On vacation in Barcelona.

The Internet provides a wealth of easily searched images.
I found one that provided a wide view of the area.
In the drawing I emphasized the shadows created
By out-jutting walls, to give a sense of depth.

When I thought I had completed this drawing,
It took a while before I noticed
I had forgotten to to add shadows to my little figures.
An easy fix.

Pen Shading

People commented that they thought pen and ink was my medium.
I read that using technical pens was the best method
For drawing smooth lines with consistent widths.

Watercolor brushes are recommended
For applying India Ink and Ink washes,
On heavy paper designed for water based media.

I bought three Rapidograph pens
For drawing fine, medium and heavy lines,
And I began to practice pen control.

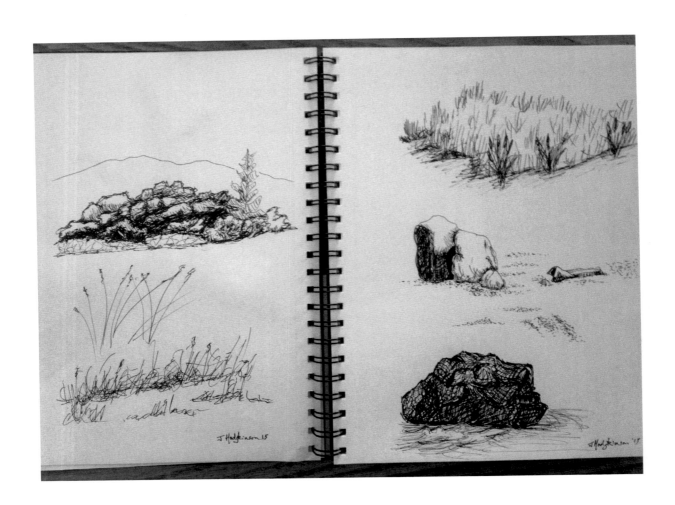

I bought a beginner's book "Drawing in Pen and & Ink", by Claudia Nice
And began to read about the use and care of technical pens.
Then I looked through the book eager to get started on learning how to use them.

I bought three dollar, hard bound, sketchbooks
To use for practice sketching and pen practice.
They are intended for dry media but also work with the pens.

I begin to practice using the pens
Using repetitive shading drills
And simple landscape elements like grasses and rocks.

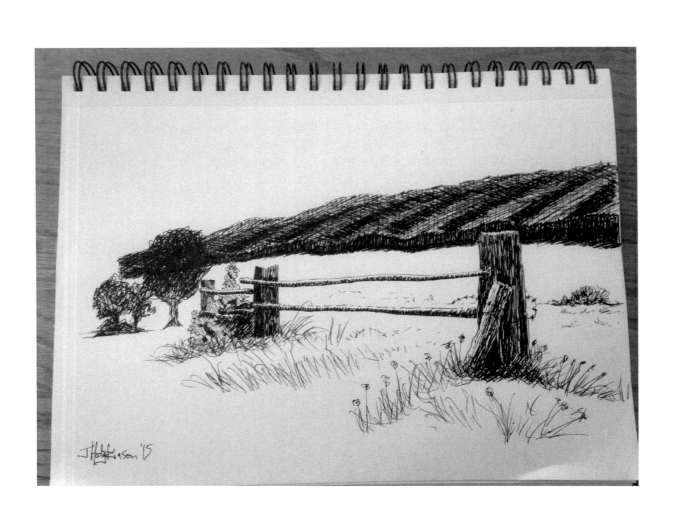

56

This pen drawing
Was a based on a project
From Claudia Nice's book,
"Drawing in Pen & Ink"

Over working the drawing,
Trying to improve the shading
Produces too much uniformity,
And not enough contrast to look natural.

Knowing when to stop
Seems to be
Surprisingly difficult
There's an insight to be had there.

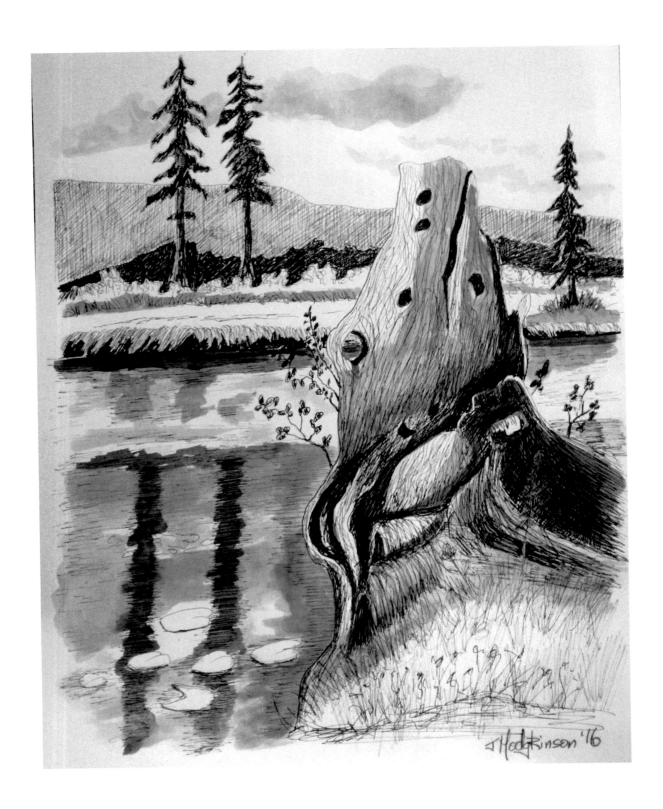

58

This drawing, also
Based on a study from "Pen & Ink Drawing",
Is more successful in terms of the interest
Aroused by varying the shading technique and its tone.

Maximum contrast,
Dark on white,
Makes the dark objects
Stand out.

Movement

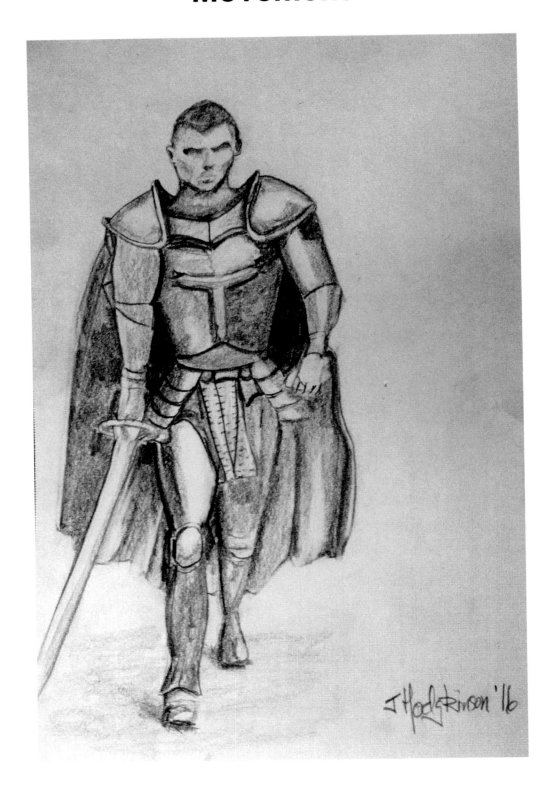

Movement adds life
To your figure drawings.
A cityscape scape comes alive
When it's populated by figures in motion.

You're trying to
Catch the figures in mid stride
Looking a little off-balance
Otherwise they are static and looked posed.

Not that this is
Easy for me to achieve.
It's something I practice frequently
Hoping to capture an animated snapshot of time.

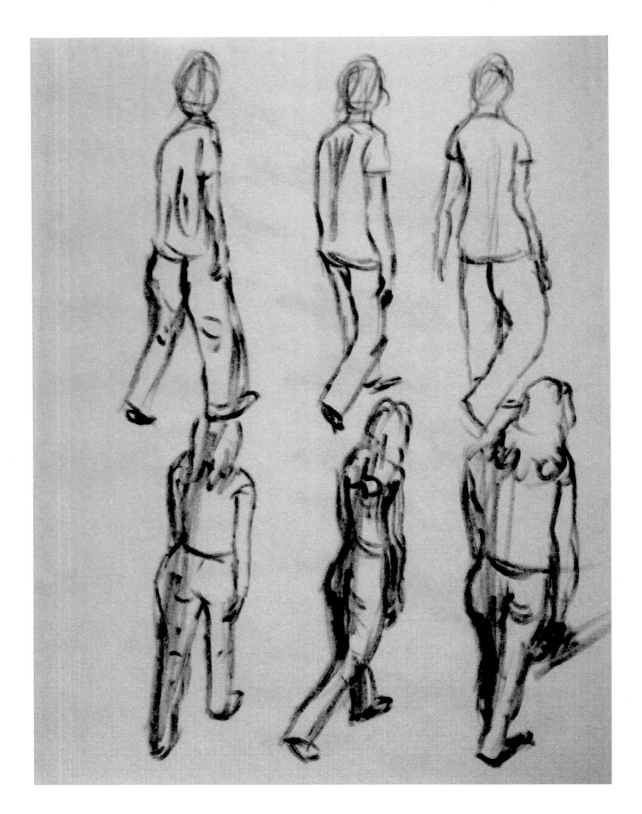

Drawing walking figures is something I practice.
These are larger than those I typically draw in cityscapes,
But they make the leg and arm positions clearer.

In analyzing how to represent motion, I find
Myself observing people walking
Towards and away from me.

Noting which arm goes back as each leg goes forward.
And the position of the feet, rising up off the toes
Then striking the ground with the heel after moving the leg forward.

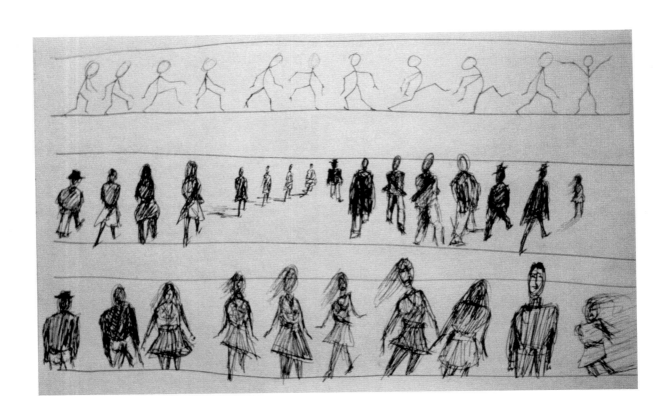

Practice is fun
If you make it fun.
A process of discovery
Looking for that nugget of gold.

Like variations in classical music
Or Jazz improvisation.
Start out playing the theme
Then just go with it.

I draw figures coming and going
Side view and full view
Moving and stationary
And look to see if they show the differences.

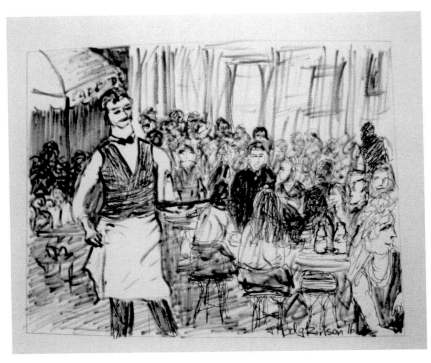

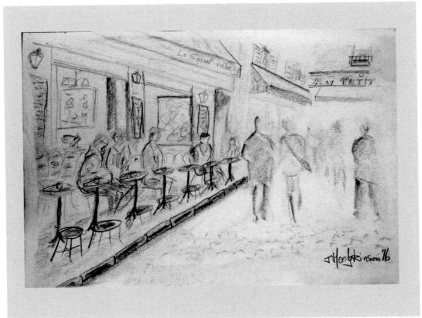

The Paris cafe scene
Makes a nice contrast
Between the busy moving waiters
And the seated but animated clientele.

And also the seated patrons
Watching the movement
Of others on the sidewalks
Is an interesting contrast.

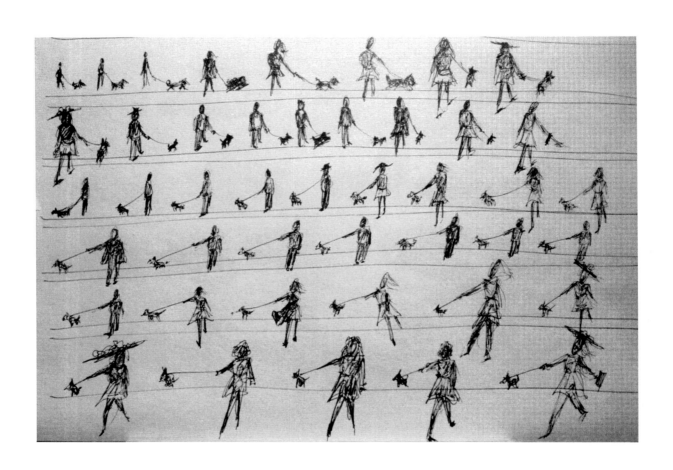

One of the things I like about Utrillo's paintings
Is that they are populated
With ordinary people in movement,
Out and about doing their daily business.

So I'm keeping that in mind for my own drawings.
To show ordinary bourgeois people
Out strolling, shopping or enjoying an evening with friends.
This practice sheet is a beginning.

Emotion

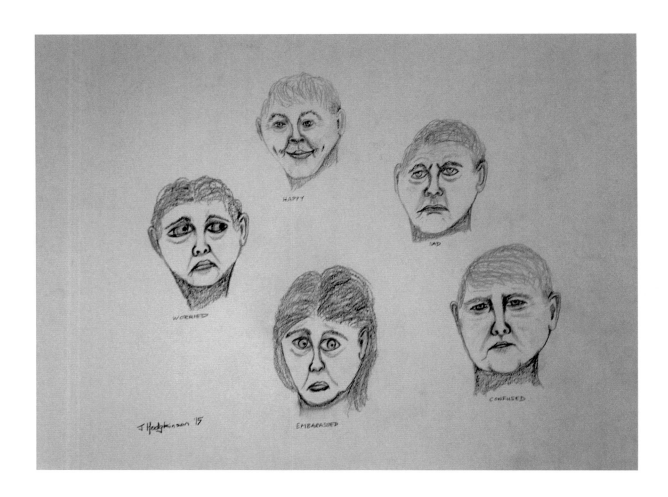

Our teacher E. J. Gold
Suggested we draw the facial expressions
Associated with happiness, sadness,
Confusion, embarrassment and worry

To explore the facial expressions
 I used a mirror and generated
The masks with my own face.
Actors should find this easy.

It's interesting to see
How relatively small changes
In the eyes, eyebrows, forehead and mouth
Can convey such a wide range of emotions.

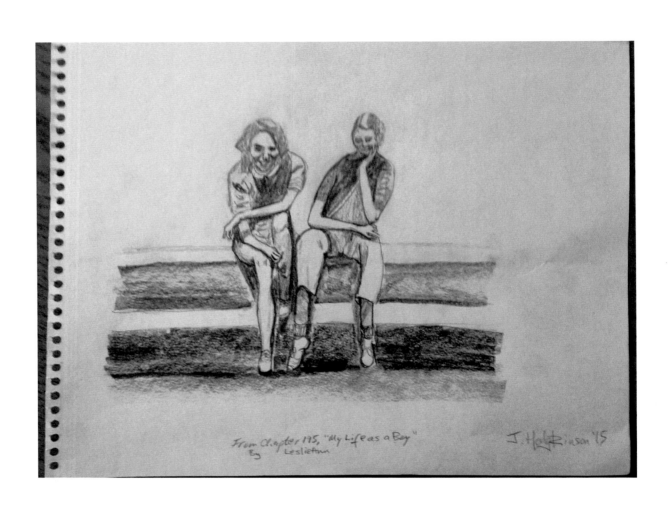

From Chapter 195, "My Life as a Boy"
By LeslieAnn

J. Hotchinson '15

There is an abundance of photographs in the print media
As well as the internet and family photo albums.
E.J. Gold's book "My Life as a Boy" was created from
A large collection of personal and family photographs.

I found this book a useful source of images
To review for drawing subjects.
I liked the warm connection I felt between these two young women,
In this photo from the book.

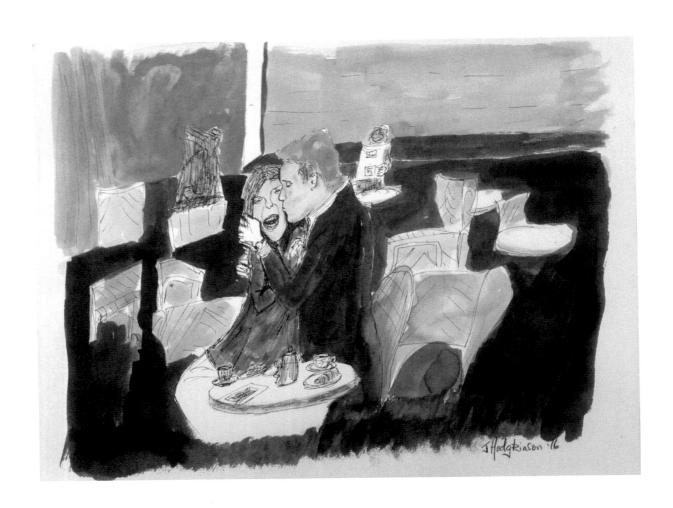

At an empty restaurant in Paris
She is overjoyed that he is
Demonstrating his love for her.
But is he sincere?

The couple is the focus of the drawing.
I down played the detail
In the surroundings
To bring out their emotion in this moment.

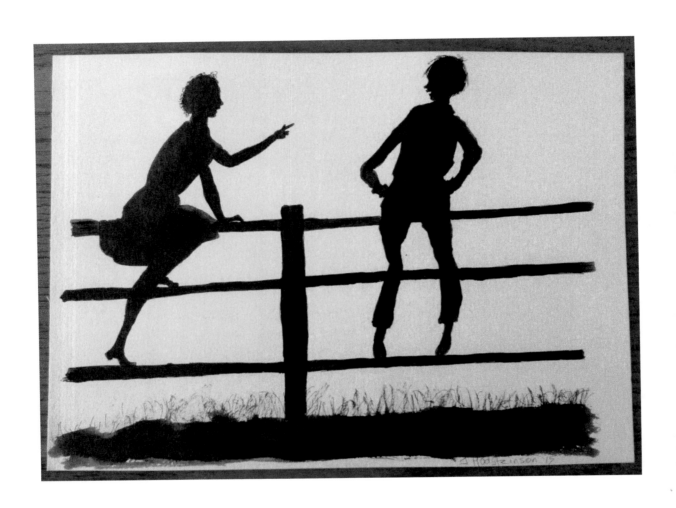

Facial expressions are not the only clues
We reveal about our emotions.
Body language also conveys information.

This drawing is from
A children's book called "Dunderpate"
Illustrated solely by silhouette drawings.

In this drawing Susan
Is forcefully saying something
While Dunderpate reacts passively.

Onward

Putting it all together, the following pages bring you up to date on where this path has brought me at the time of writing this book. Currently I'm specializing in pen and ink drawings and sometimes I add a little color to them using soft pastels. This is especially so for my Canary Island drawings which seemed to cry out for sunshine and color. However Montmartre, Paris at night, seems perfectly content to be in street-lit darkness.

But first for all you artists, a few words about my creative process.

I follow these steps to create a drawing from a photograph.

1. Crop the photograph to select the area of interest and match the dimensions of the drawing.
2. Draw light pencil lines blocking out the largest objects in the drawing and getting their perspective and relative positions correct.
3. Ink the lines with pen then erase the pencil lines.
4. Complete the detailed inking with pen.
5. Apply diluted washes by brush.
6. Highlight with a small brush any areas needing undiluted ink.
7. Apply soft pastels to areas needing color (if required).

1. Draw Light Pencil Lines to Block the Drawing

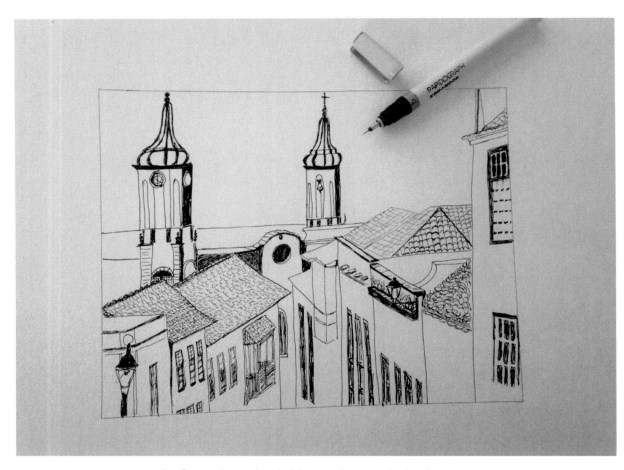

2. Complete the inking using technical pens.

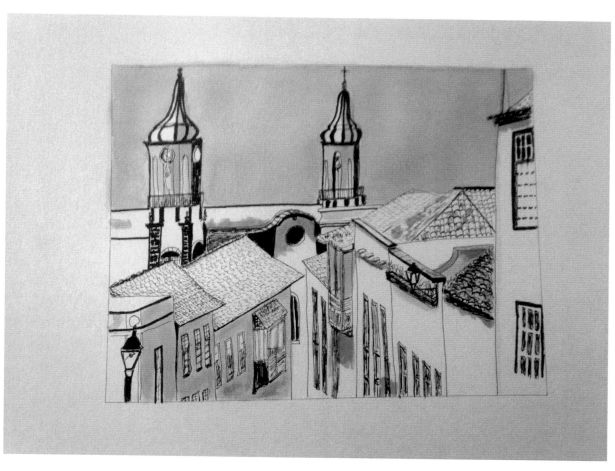

3. Apply washes with a brush

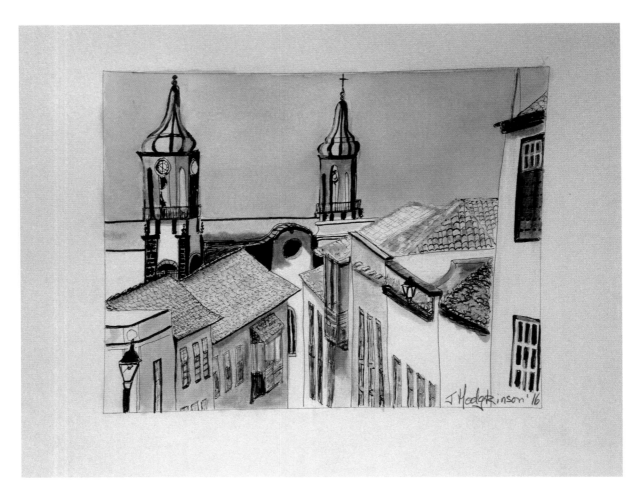

4. Apply soft pastels to complete the drawing.

Montmartre

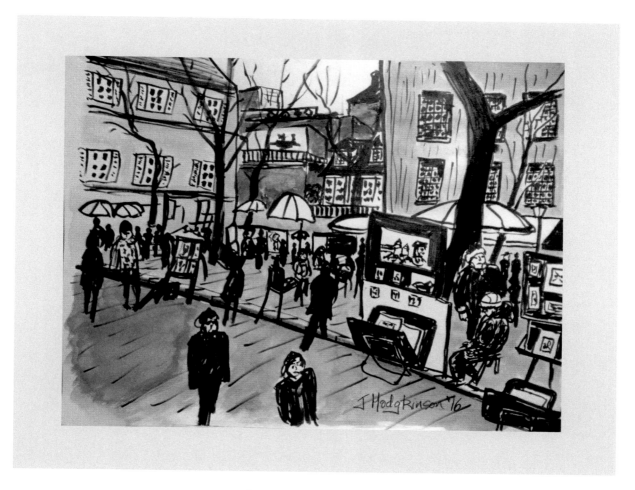

Square Tertre

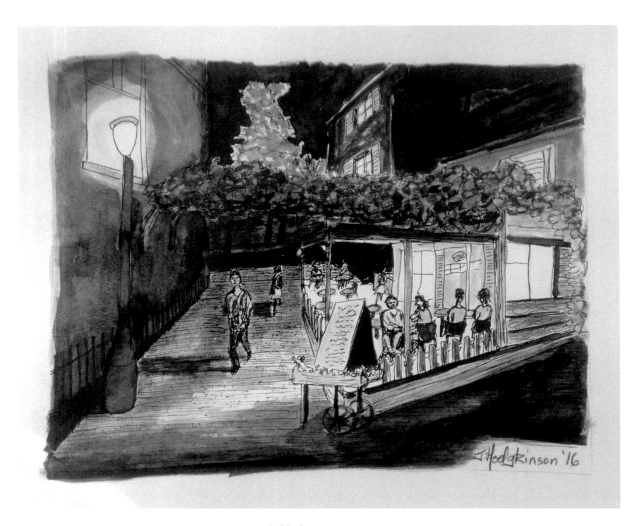

Hideaway

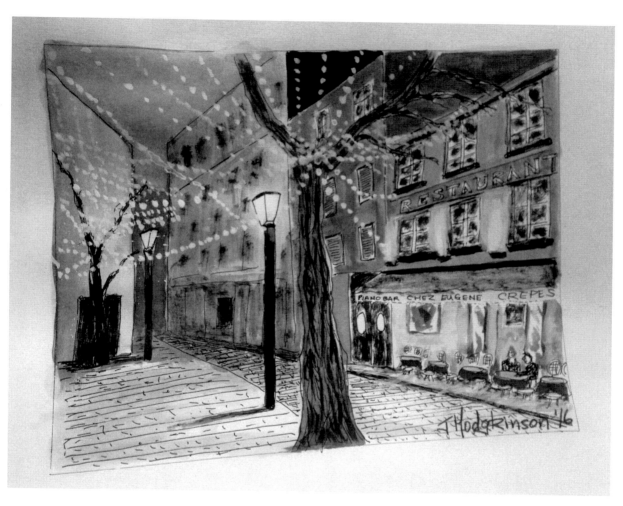

Chez Eugene

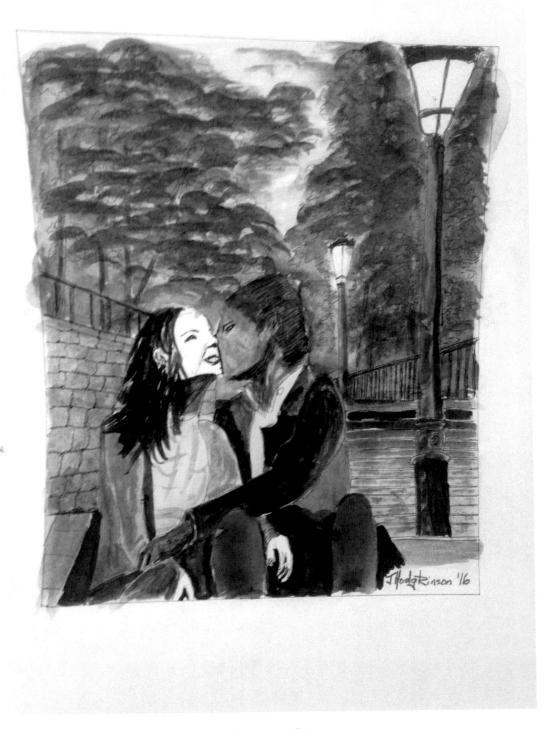

Couple on Steps

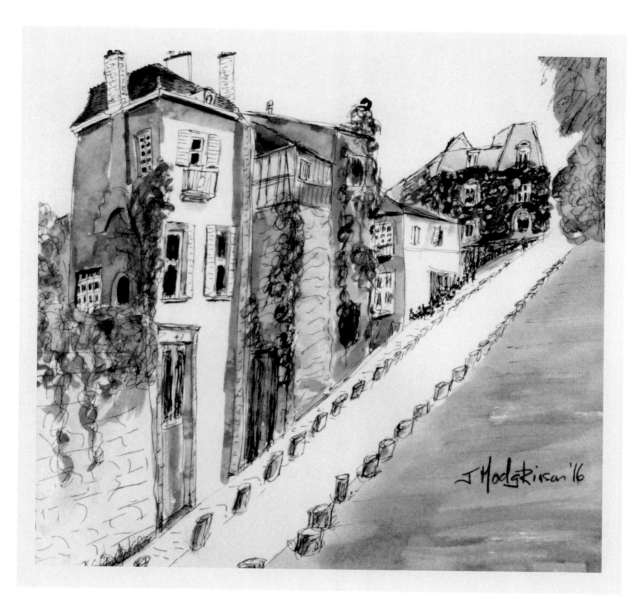

Utrillo's Montmartre

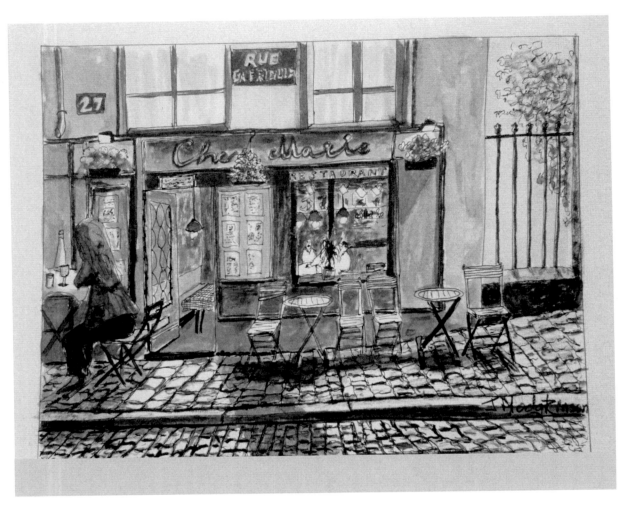

Chez Marie

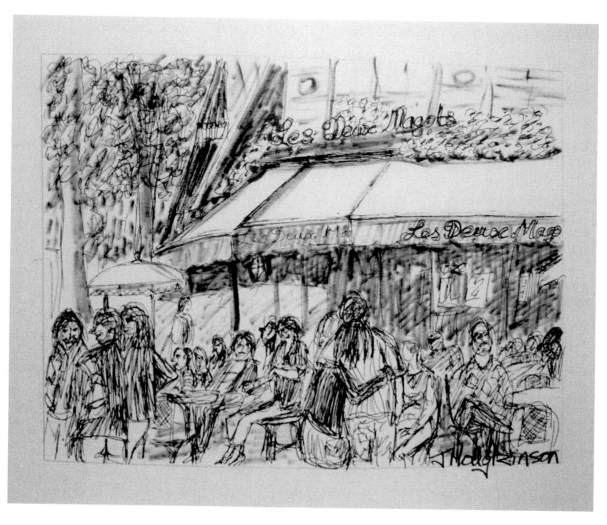

Les Deux Magots

Canary Islands

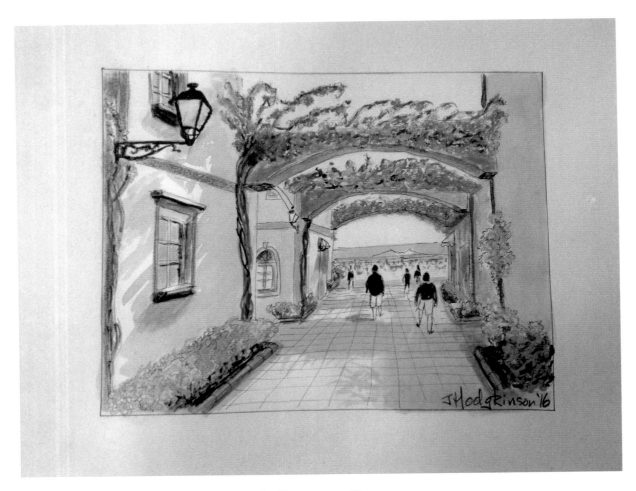

A Sunny Day

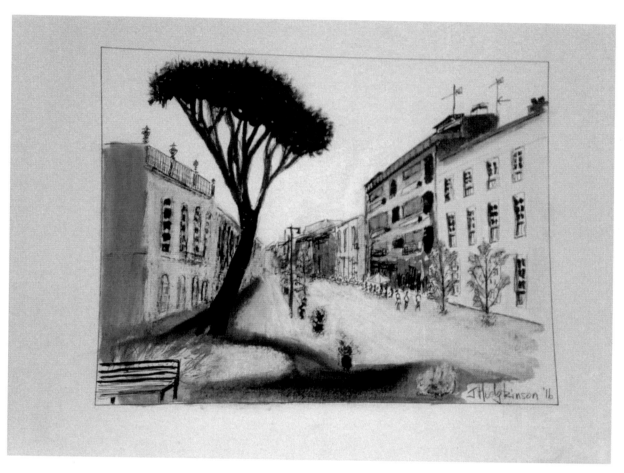

Tenerife Street

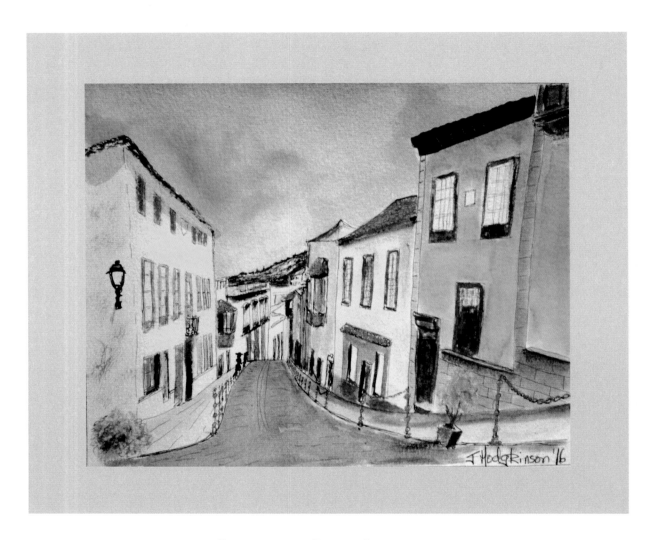

Streets of La Orotava

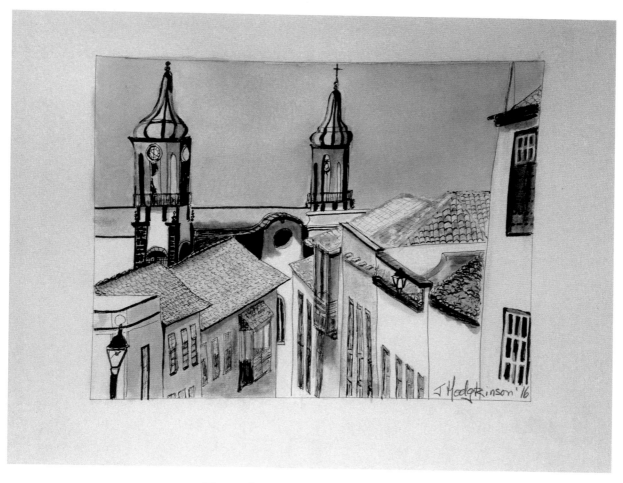

Roofs of La Orotava

Afterword

If you are a beginning artist and are wondering where to start I recommend that you get a copy of "Draw Good Now" by E.J. Gold, as I did and start doing the exercises. Spending a few minutes each day seems to produce the best results. I continue to practice the exercises as often as I can, finding them both pleasurable and relaxing to do.

"Draw Good Now" emphasizes pencil shading techniques. The student can photocopy or scan the unshaded line drawings then try to reproduce the shaded drawings shown next to them. There are 78 exercises of increasing complexity, starting with simple "scribble" forms. Both foreground and background shading is covered. About half the exercises are of the human body. The remaining subjects are landscapes, portraits and still-life.

A good complement to the book are a series of videos on YouTube which feature Mr. Gold teaching beginner's art classes. His conviction that you can draw may be just what you need to get drawing.

The back page of this book has information on where you can obtain "Draw Good Now" and other art books by E.J. Gold.

Dear Reader:

To find out more about E.J. Gold's art classes and instructional materials, visit the websites listed below or contact us directly:

Gateways Books
P.O. Box 370
Nevada City, CA 95959-0370

Phone: (800) 869-0658
 (530) 271-2239
Fax: (530) 272-0364

Email: info@gatewaysbooksandtapes.com

Website: www.gatewaysbooksandtapes.com

The Editors, Gateways Books